LOCUS

LOCUS

LOCUS

LOCUS

catch

catch your eyes ; catch your heart ; catch your mind······

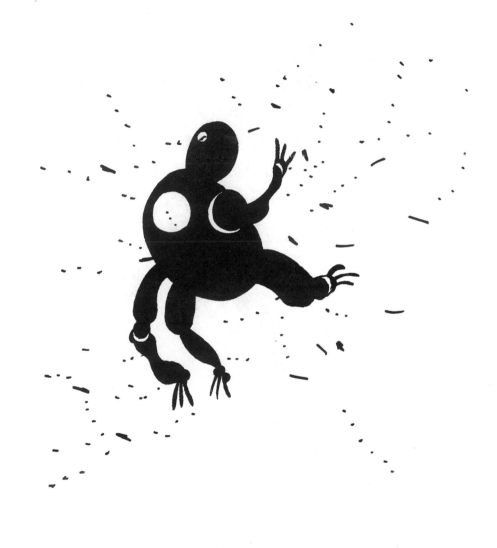

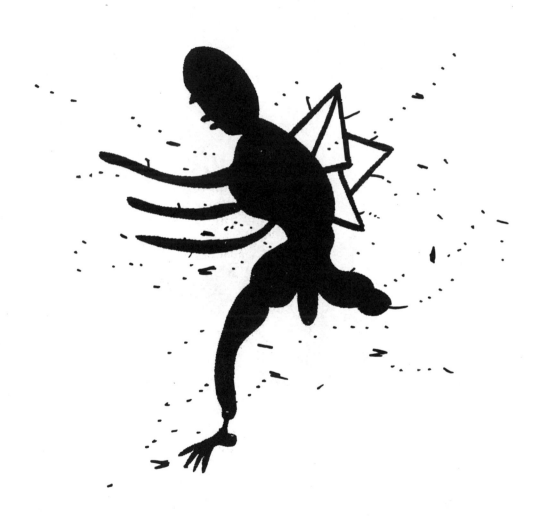

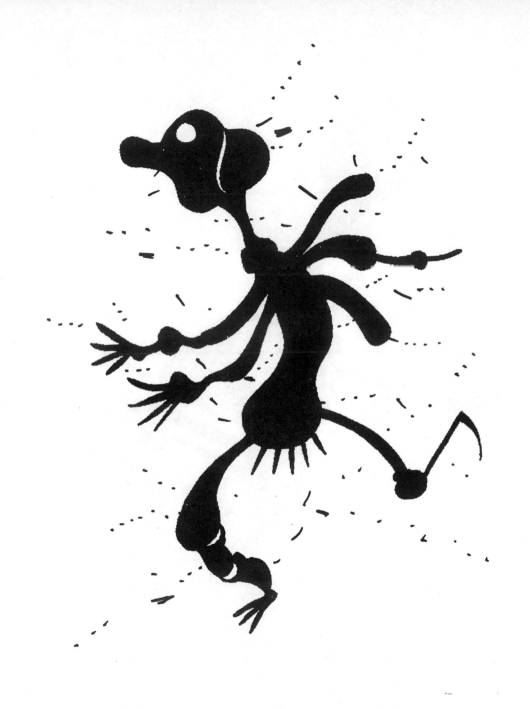

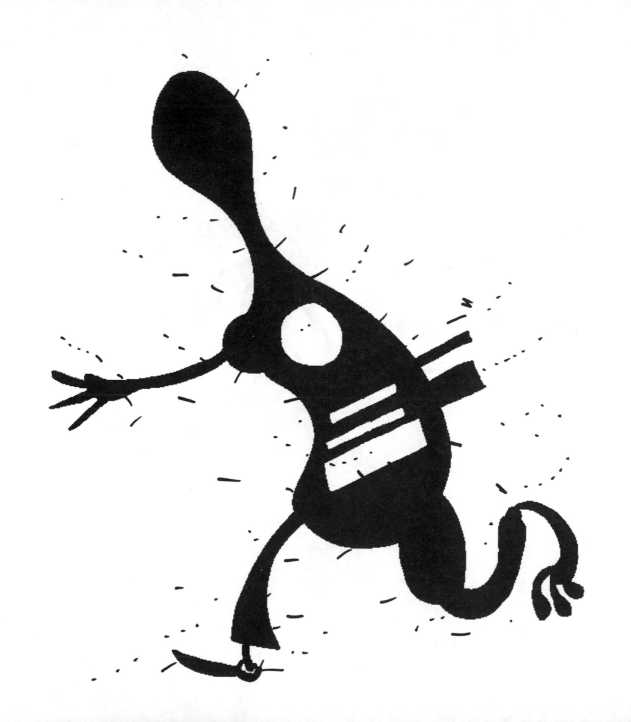

目錄
CONTENTS

- 隱形 THE INVISIBLE
- 一曲歌神 Sing-a-Song
- Twins 孿生
- 傻到死 LOVE TILL DEATH
- 病 SICK
- 數目 Numbers
- 地球之友 FRIENDS of Earth
- 賊相 A Thief Look
- 接觸 Touch
- 秘密 SECRET

- 情人節之外
 Valentine's Plus
 - 石頭記　Rocky
- 言語　speakeasy
 - 會　meeting
- 浴血古龍水
 Bloody Cologne
- 創作人
 Talent
 - 歷史　History
 - 命運　Destiny
 - 花事　Flower affair
 - 間諜　Spy

- 夢 Dream
 - 巴士司機 Bus Driver
- 無語 Not a Word
 - 失落 Depression
 - 蛋糕 CAKE
 - 停電 Black out.
 - 小明的新衣 SIUMING's new Clothes
 - 說故事 Story Telling
 - 赤裸裸 THE Naked Game
 - 動物園 ZOO

- Sleep 睡
 - 床邊故事 Bedtime Stories
 - 來客 man from Mars.
 - 蛻蛻變 Malmetamorphosis
 - 四個 Four
 - 分享 share
 - 探險家 Explorer
 - 死 dead
 - 身份 ID

（序）當小明和小明在一起

小明小明小小明，上上下下左左右右前前後後
火車穿山洞！
兒時的一個順口溜猜拳遊戲，
衍生成今日這裡一筆那裡一劃，
筆筆劃劃成為故事，成全了小明。
眾生皆是小明，小明就是你我，
復雜不過簡單不過，
小明只是一個名字。

應霽 97

Intro

When SinMing meets SinMing

SinMing Sin Ming Sin Sin Ming
Ups and downs, left and right, to and
fro,
trains passing through a tunnel!
A nursery rhyme from the good old days
evolves into sketches here and there,
becomes different faces of SinMing.
Everybody here is SinMing, SinMing is you and me.
So complicated yet so simple.
Sin ming is just a name.

Craig 97.

小明
SIUMING

隱形
THE INVISIBLE

小明是個隱形人．
Siuming is an Invisible man．

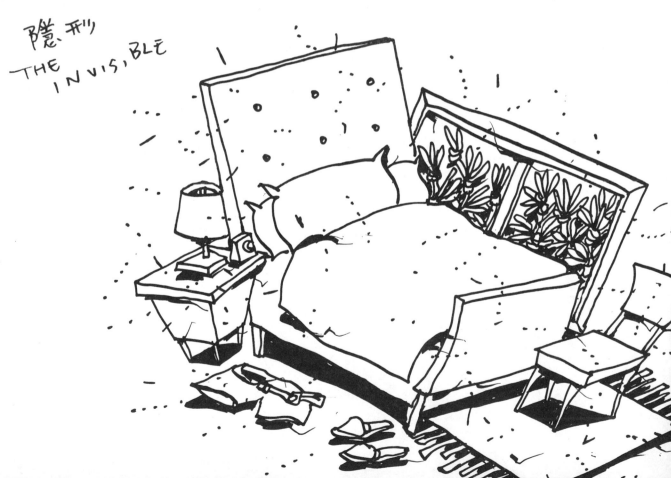

聽說他長得異常俊美.

It is said that he is
stunningly handsome.

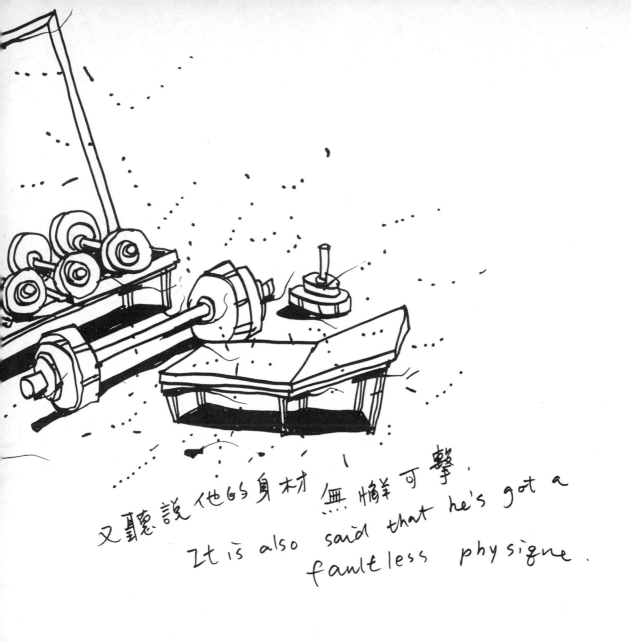

又聽說他的身材 無懈可擊.

It is also said that he's got a
faultless physique.

他的醫生說替他動手術是
天下第一難事。

His doctor claims that to perform
an operation on him
is the most difficult task
he has ever encountered.

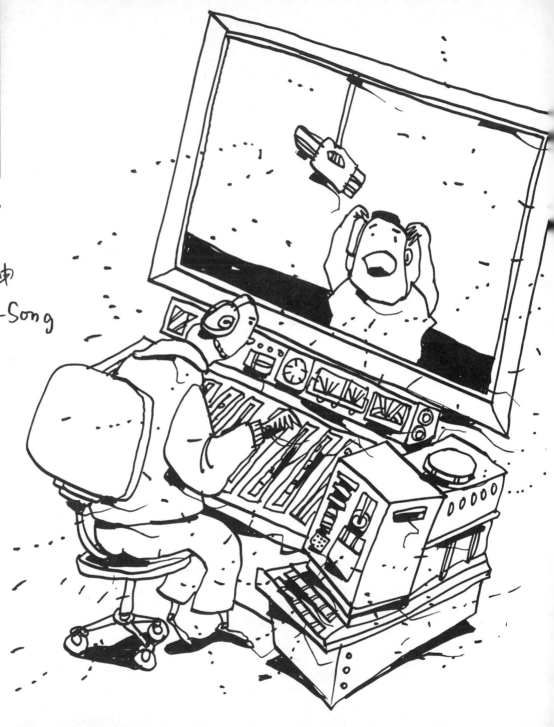

小明早在四岁時候就
推出他的個人單曲，
Siuming released a CD single
when he was FOUR.
這首歌一出就庄連佔榜首
銷量奇佳。
The song was a sudden hit
and it topped every chart and sold
millions and millions
of copies.

小明一夜成名更成為圈中最年輕首富。

It brought overnight fame and fortune to Sinming and made him the youngest billionaire in the show business.

自此 他從未錄（也不需錄）第二首歌。

He did not (and didn't need to)
record a second song for the rest
of his life.

小明
SIUMING

Twins
孿生

小明和小明
是孿生兒

Siuming and Siuming are twins

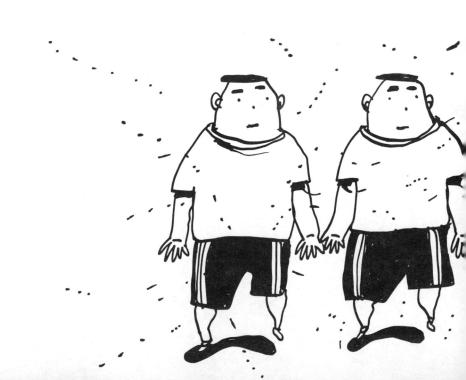

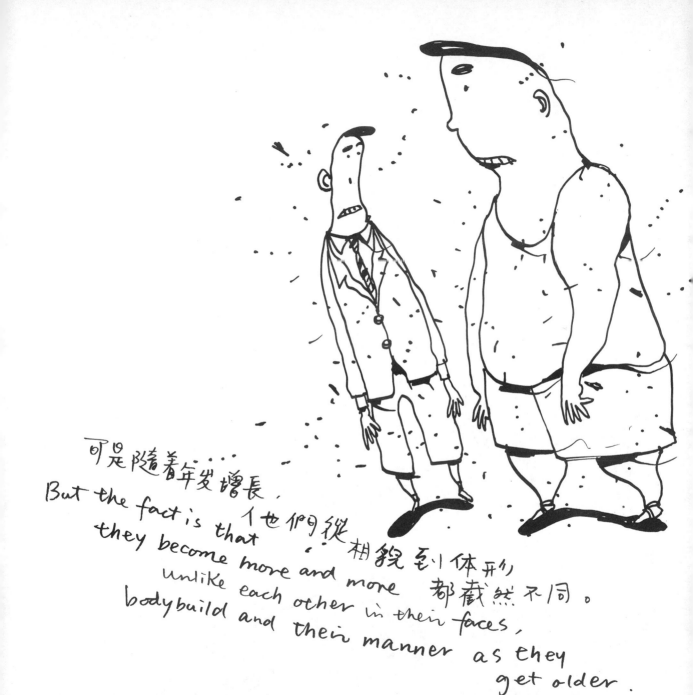

可是隨着年歲增長，他們從相貌到体形　都截然不同。

But the fact is that they become more and more unlike each other in their faces, bodybuild and their manner as they get older.

他們對這個殘酷的事實，
　　都表現得很傷感。

They are too sad
　　to accept
　　　　this fact.

他們決定結束這段關係。
They decide to end their relationship.

小明
SIUMING

LOVE TILL DEATH

愛到死

魚。小明深深的愛著八爪魚小明。
SiuMing the fish was deeply in love with SiuMing the octopus.

它們同甘共苦直到最後一刻.
They shared the sour and sweet
Until the very last moment
of their life.

天意安排它們一同變成 美味的 海鮮飯

Even the Lord has made them together in a delicious seafood risotto.

可是刁鑽的顧客X小姐
覺得八爪魚實在難消化.

But the picky customer Miss X
thinks the octopus is difficult to digest.

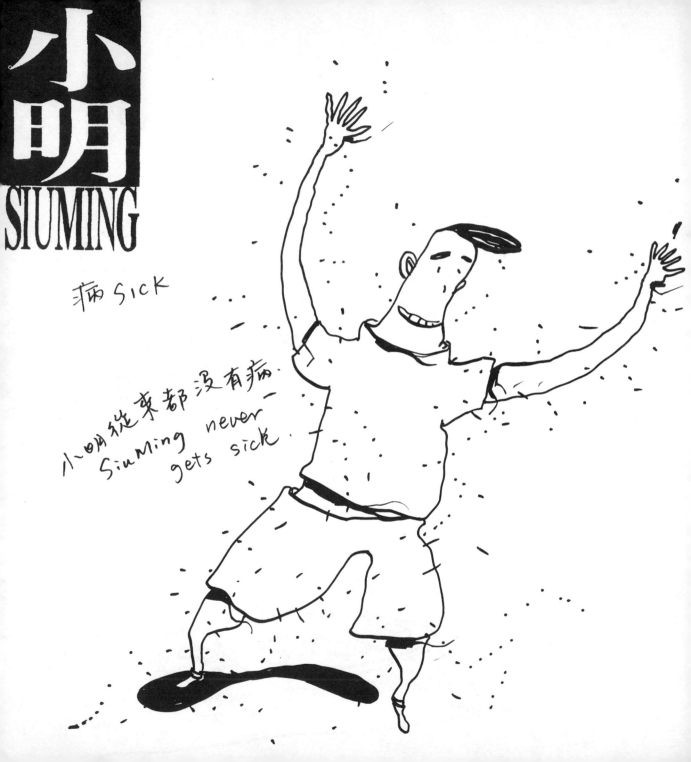

小明
SIUMING

病 SICK

小明從來都沒有病
Siuming never
gets sick

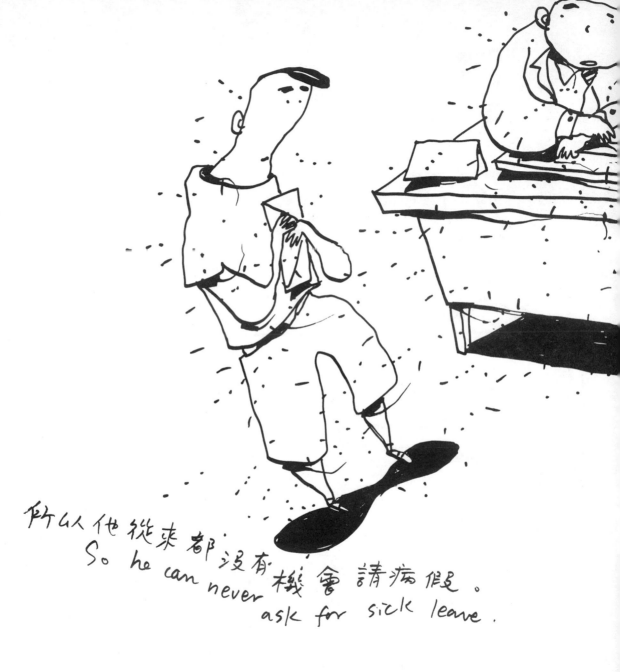

所以他從來都沒有機會請病假。
So he can never ask for sick leave.

因為沒有病的親身經驗
看來也不能做一個好醫生。

He is so sad that
he thinks he cannot become
a good doctor without having
been a sick person.

唯有情情吃一些其實, 他並不需要吃的薬.

He gets into the habit of
secretly taking many pills
he doesn't need.

小明
SIUMING

数目 NUMBERS

小明每天都在数手指
Siuming counts
her fingers
everyday

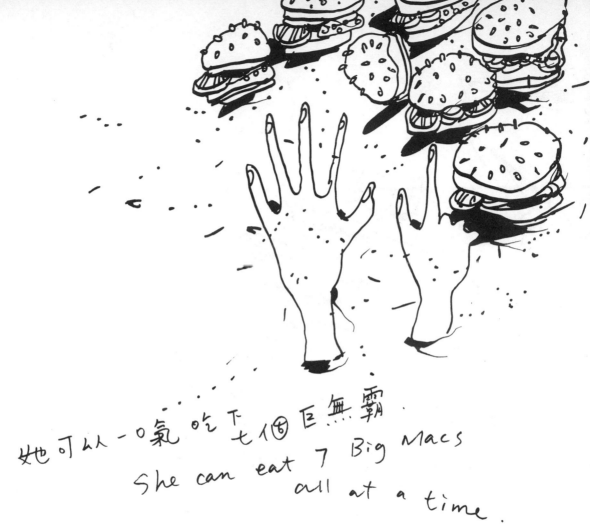

她可以一口氣吃下七個巨無霸.
She can eat 7 Big Macs
all at a time.

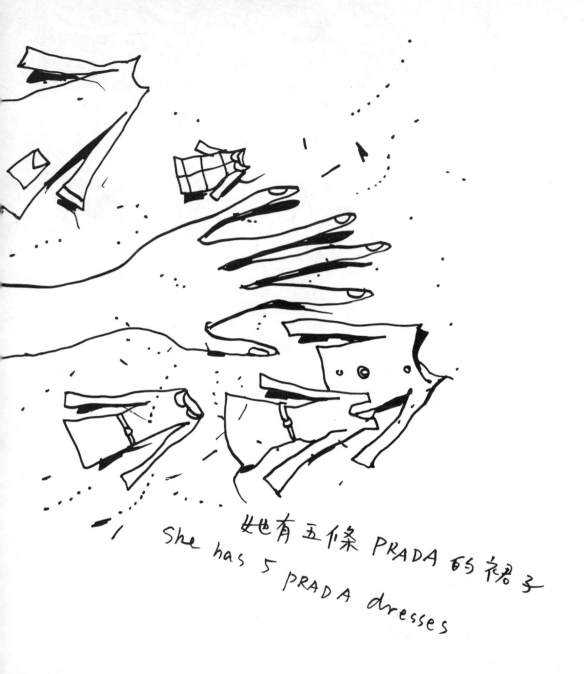

她有五條 PRADA 的裙子

She has 5 PRADA dresses

她有三分一個知心朋友
she has only one-third
of a heart-to-heart
friend.

小明
SIUMING

地球之友
FRIENDS OF EARTH

小明終於發覺地球是方的！

Siuming finds that the Earth is a cube...

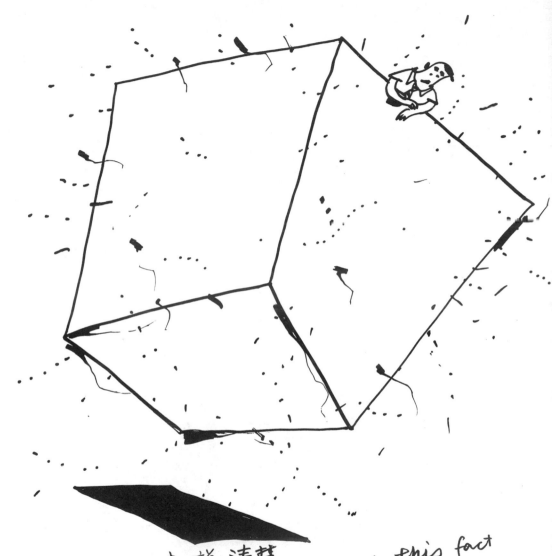

但他始終不敢站出來 說清楚
But he dares not put forward this fact
in public.

他只能偷偷動用公帑
組成十八人專責小組。
What he can do is secretly use
the public revenue
to form a consultation board
to examine this issue.

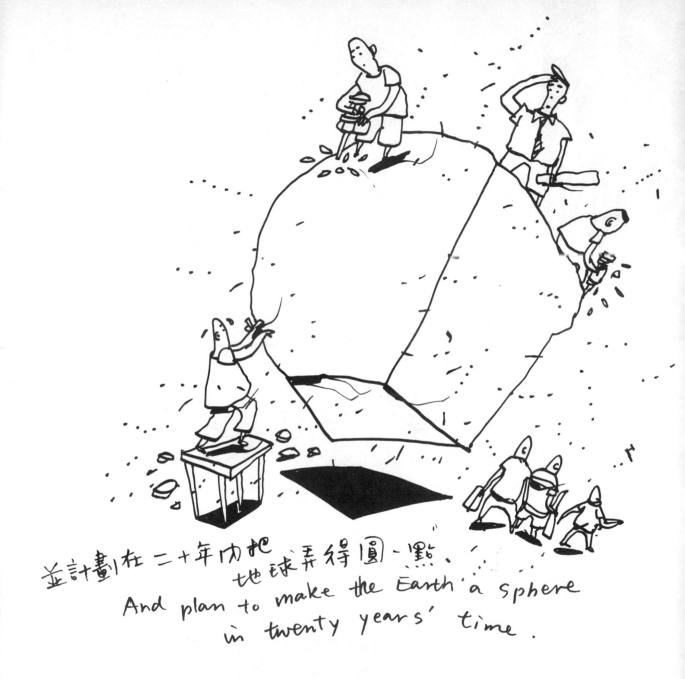

並計劃在二十年內把
　　　地球弄得圓一點、
And plan to make the Earth a sphere
　　in twenty years' time.

小明
SIUMING

賊相 A THIEF LOOK

小明是個賊，而且是一個長得十分漂亮的賊。

Siuming is a thief and such a handsome thief.

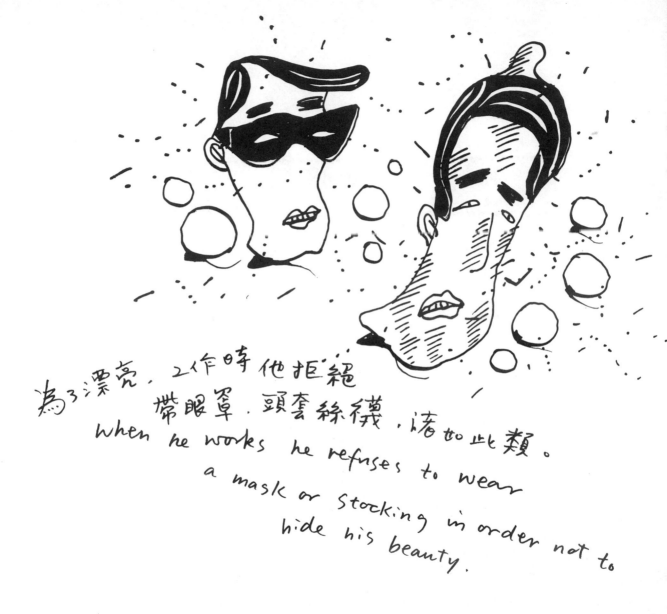

為了漂亮，工作時他拒絕
帶眼罩．頭套絲襪，諸如此類。
when he works he refuses to wear
a mask or stocking in order not to
hide his beauty.

當然⋯⋯一切後果得由他自己負責——
Of course, he is responsible for
all consequences.

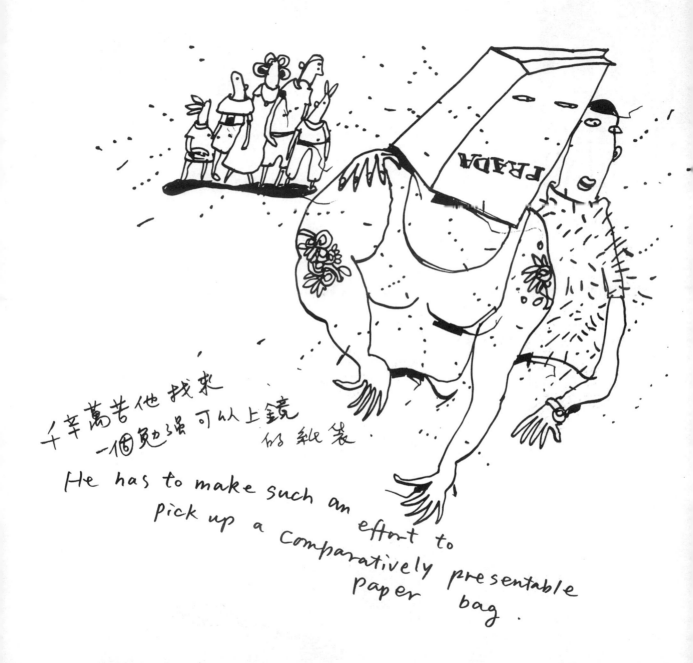

千辛萬苦他找來
一個勉強可以上鏡
的 紙袋.

He has to make such an effort to
pick up a comparatively presentable
paper bag.

小明
SIUMING

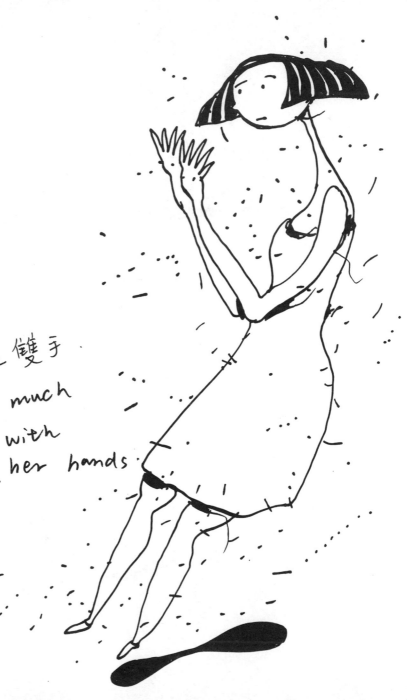

接觸 TOUCH

小明太愛自己雙手
SiuMing is so much
in love with
...her hands

她每天花兩小時去進行部運動和護理。

She spends two hours a day taking great care of them.

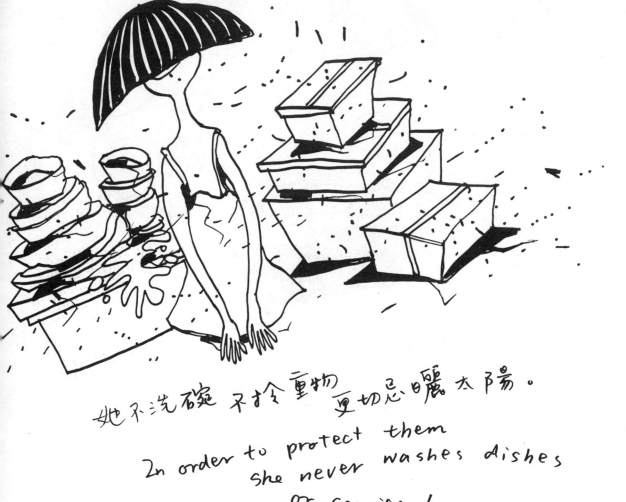

她不洗碗 不拿重物 更切忌曬太陽。

In order to protect them
she never washes dishes
or carries heavy things.
and never lets them
get sunburned.

最近她更決定不接觸任何人

And recently she decided not to touch any peaple either.

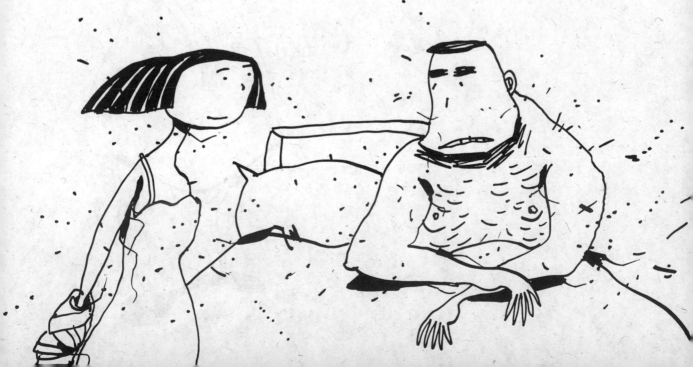

SIUMING

秘密 SECRET

小明有個秘密要跟人說

SiuMing has a
secret to tell

姊早知道了這個秘密，一定會
　　　　　　　一傳十、十傳百……

As she expects, this secret passes
from the lips
of A to B to C.

果然，在不到四個小時之內，

五十個有關或者無關的人仕

都知道了`秘密'．

It breaks the records at passing through 50 people in only 4 hours.

'秘密'終於傳回她的耳中，叫人懊惱的是
秘密一字不漏的沒有半點
誇張和歪曲。

When this 'secret'
get's back to her,
SiuMing is so
annoyed.
What she heard is
exactly the same
as what she said,
with nothing added
and nothing lost.

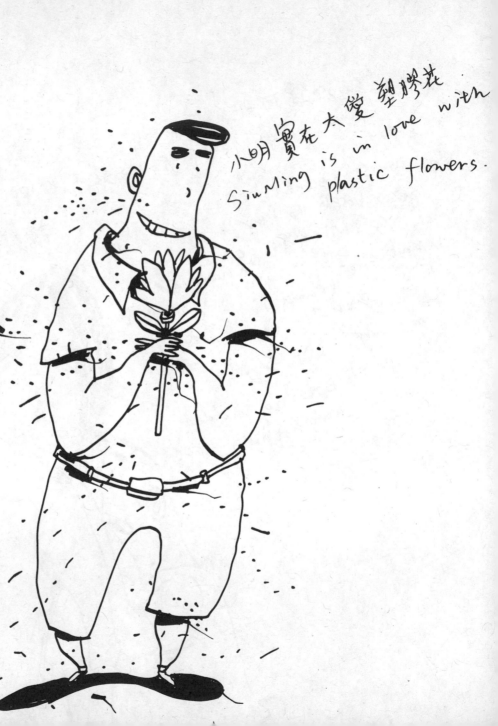

小明
SIUMING

情人節之外
Valentine's plus

小明實在太愛塑膠花
Siuming is in love with plastic flowers.

因為塑膠花燦爛直到永遠.
For they last forever and ever.

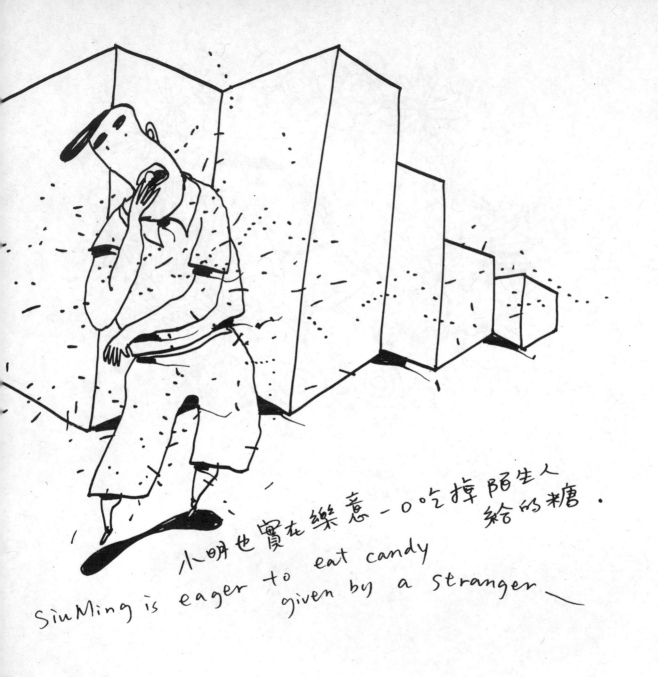

小明也實在樂意一口吃掉陌生人給的糖。

SiuMing is eager to eat candy given by a stranger.

至少這會是一個機會。

There is a chance anyway.

小明
SIUMING

石頭記 ROCKY

小明是一塊石頭，
　有天碰上國際級雕塑大師。
Siuming is a rock, one day he encounters
a world famous sculptor.

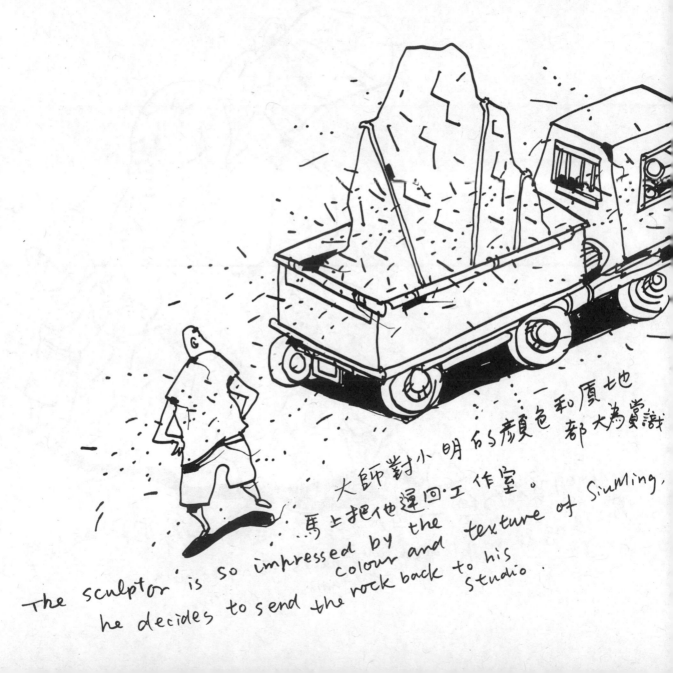

大師對小明的顏色和質地 都大為賞識
馬上把他運回工作室。

The sculptor is so impressed by the colour and texture of SiuMing,
he decides to send the rock back to his studio.

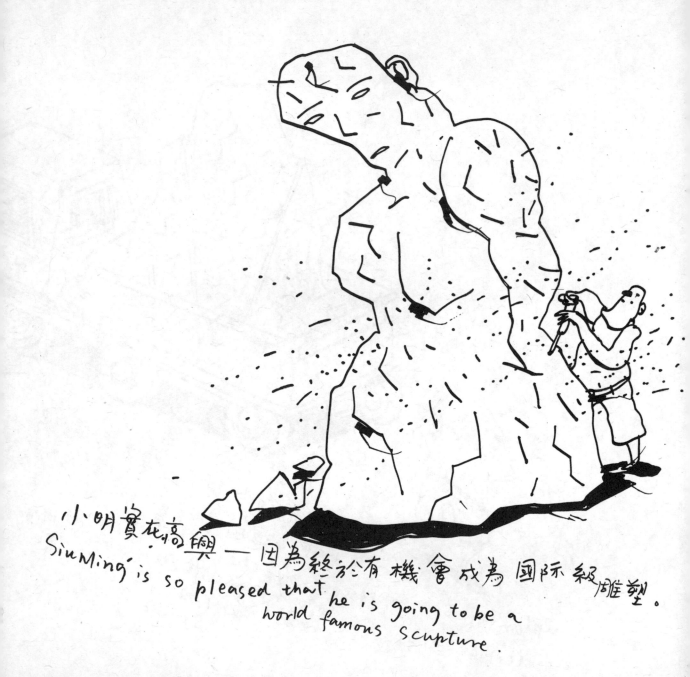

小明實在高興──因為終於有機會成為國際級雕塑。
Siu Ming is so pleased that he is going to be a world famous scupture.

可惜大師今天心情不好，
如此這般小明變了一堆碎石。
But the sculptor is in a bad mood
during the whole
working process ...
Siuming becomes pieces of
tiny rock in the end.

小明
SIUMING

言語 SPEAKEASY

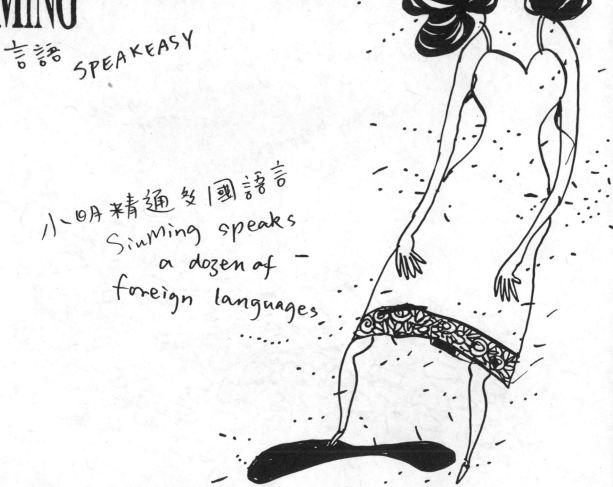

小明精通多國語言
Siuming speaks
a dozen of
foreign languages

她跟毛巾說俄文 跟公雞說英文.
She talks to the towel, in Russian and the cock in English.

她跟花說法文
跟貓說德文
She speaks French with flowers
and German with
the cat.

面對男友卻一言不發，
but speaks nothing with her boyfriend.

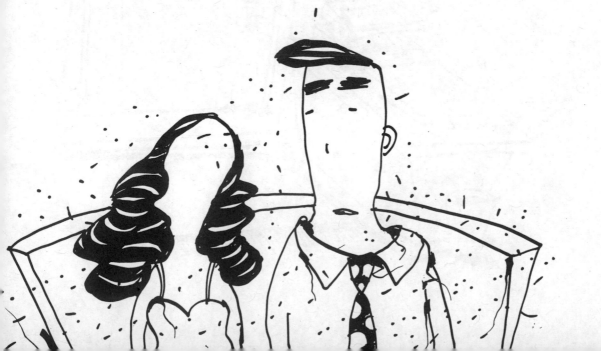

小明
SIUMING

會 MEETING

小明整個早上都在開會.
Siuming is in the meeting all morning.

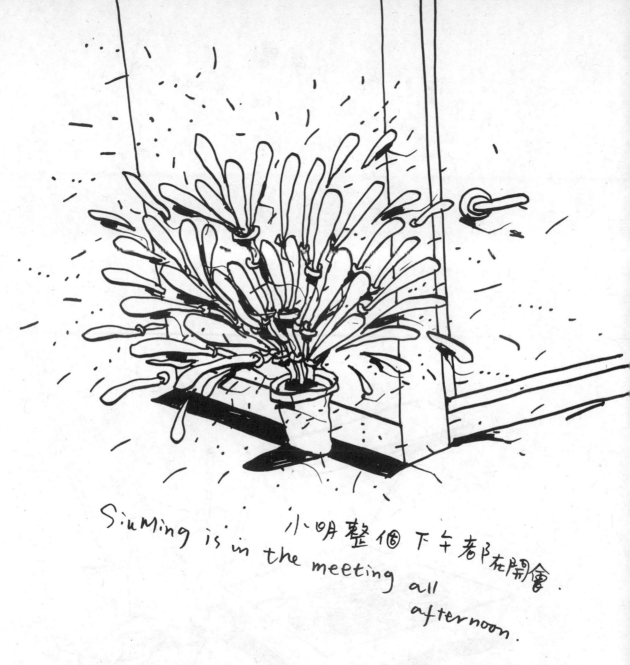

Siuming is in the meeting all afternoon.

小明整個下午都在開會。

小明通宵達旦的在開會，
Siuming is in the meeting
from dusk till dawn.

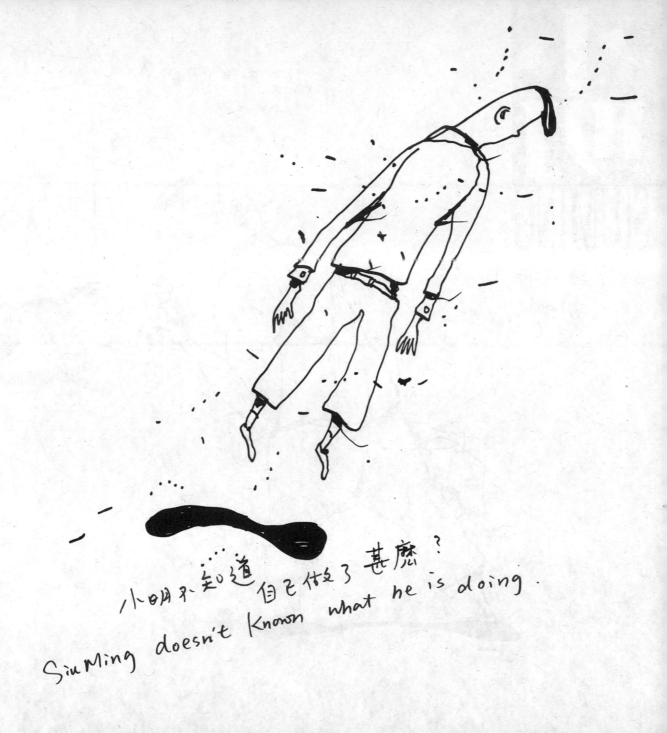

小明不知道自己做了甚麼？

Siu Ming doesn't known what he is doing.

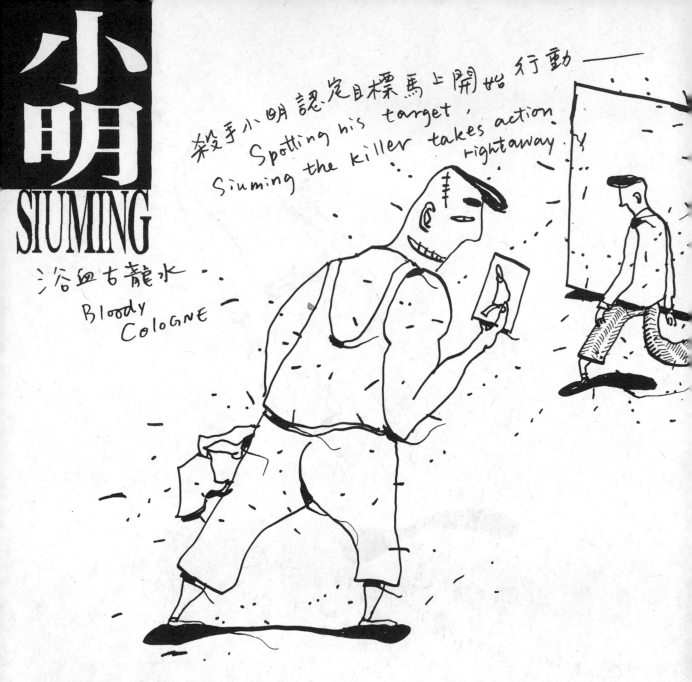

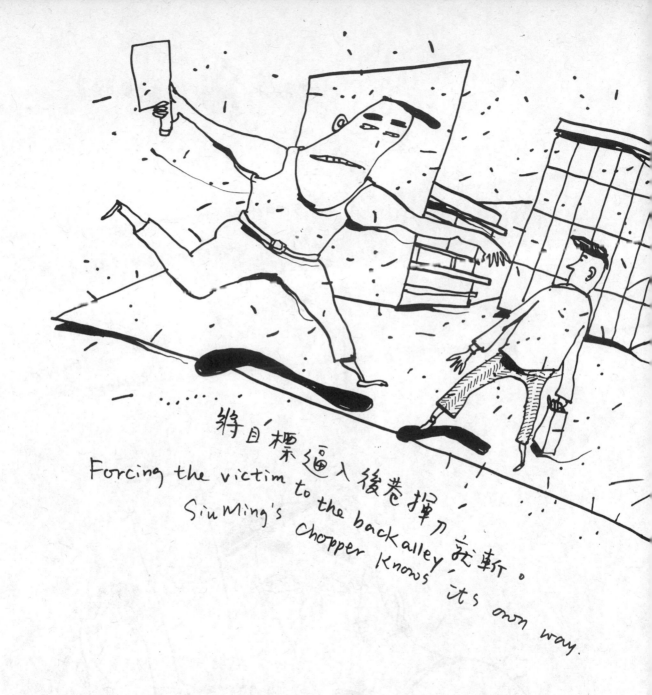

將目標逼入後巷揮刀砍斬。

Forcing the victim to the back alley
Siu Ming's Chopper Knows its own way.

電光火石之際，近距離嗅得
對方用的竟是同一隻古龍水．

All of a sudden,
 SiuMing recognizer that
the guy he is going to kill
 wears the same cologne as
 he does.

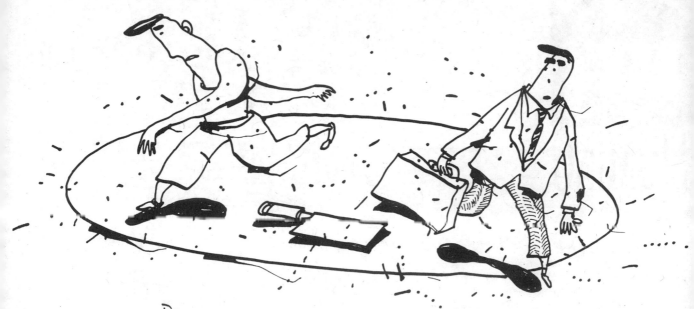

既然…如此，一切恩怨也就烟消雲散。

For such a reason,
all the hatred has
evaporated.

小明
SIUMING

創作人
TALENT

小明是個超級創意人，
他同時是時裝設計師/建築師/
音樂家/演員/作家……

Siuming is such
a talent, he is a
fashion designer / Architect /
Musician / actor /
writer……

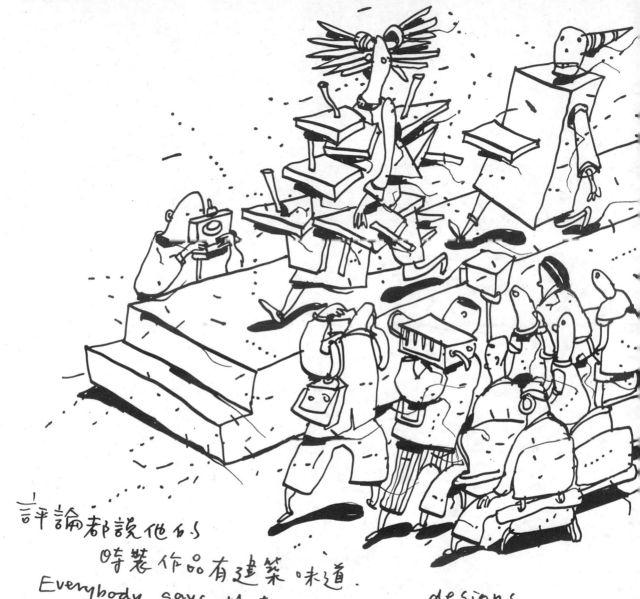

評論都說他的
時裝作品有建築味道.
Everybody says that his fashion designs
are like architecture.

他的建築作品有音樂感，
音樂也像時裝般色彩燦爛。

The house he builds is
like music,
and the music he plays
is as colourful as
his fashion designs.

他實在太有創意,
　　　結果甚麼都是,
　　　　　甚麼都不是。
He is so creative
he is everything
and he is nothing.

SIUMING

歷史 HISTORY

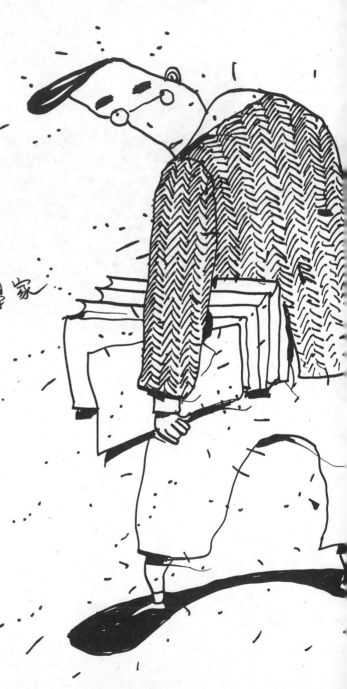

小明注定是個歷史學家...
Siuming is born
to be
a historian.

凡是過去了的　才會引起他的興趣。

Only things from the past can arouse his interest.

例如是一隻死了的貓，一朵枯了的花
和一個死了的人。
A dead cat, a withered flower
and a corpse,
to name but a few.

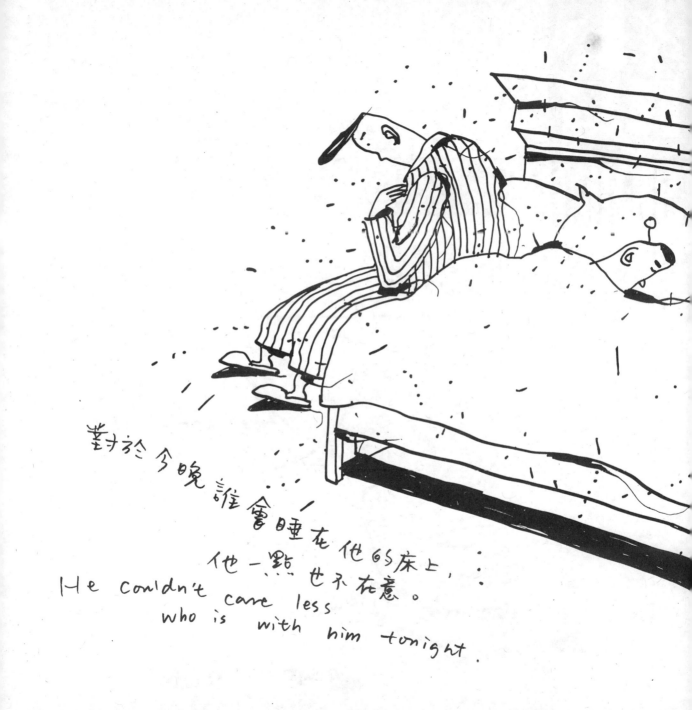

對於今晚誰會睡在他的床上，
他一點也不在意。
He couldn't care less
who is with him tonight.

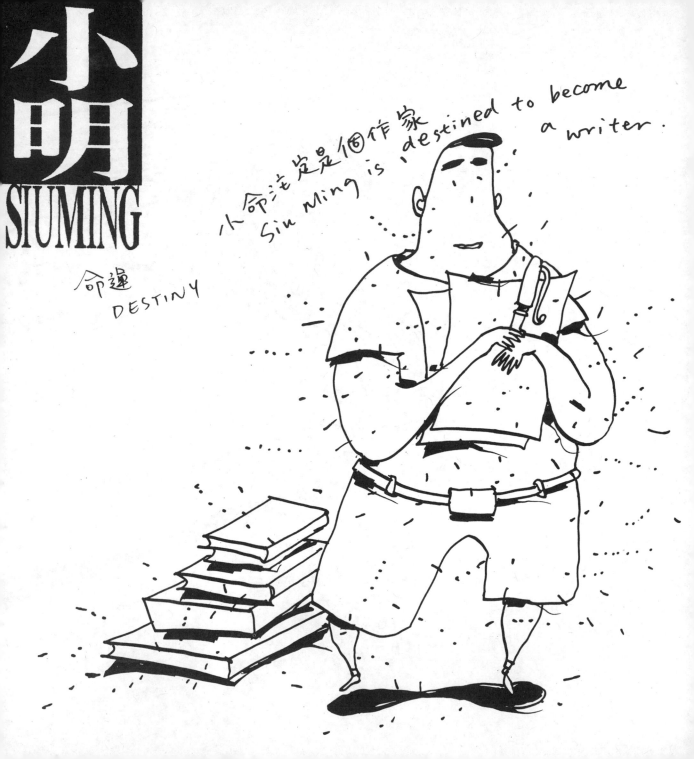

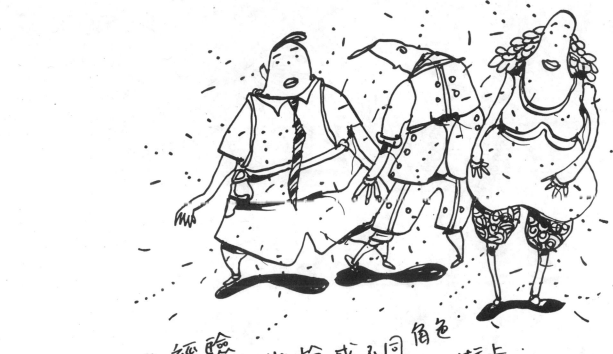

為了增加人生經驗⋯⋯
他經常裝扮成不同角色
走到街上⋯⋯

In order to get experience from all
walks of life, he disguises
himself as different characters
from time to time.

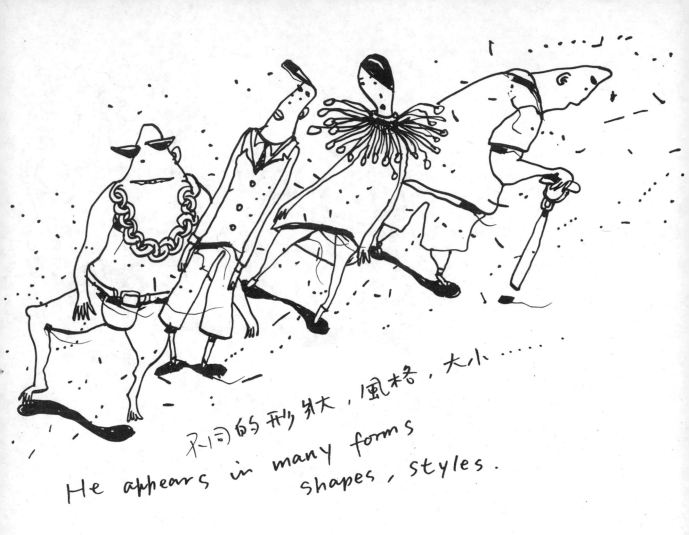

不同的形狀，風格，大小……
He appears in many forms shapes, styles.

結果書只賣出了幾本，
　　小明卻成了世界一流的
　　　　化粧大師。

He ends up selling only a few
copies of his book but becomes
a world acclaimed
make-up artist instead.

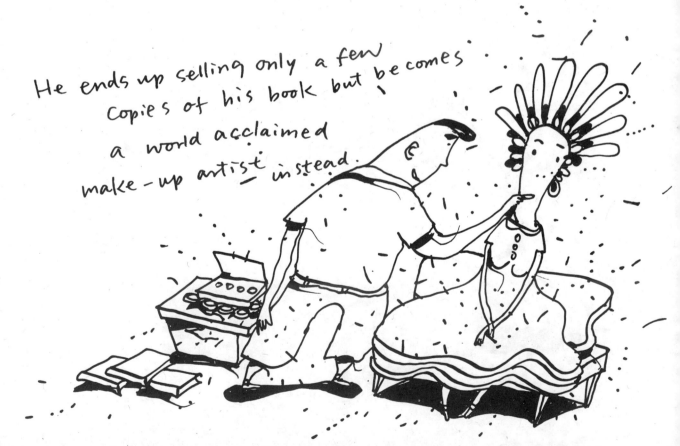

小明
SIUMING

花事
FLOWER AFFAIR

詩人小明看見一朵花
Siuming the poet sees a flower

正要開始寫一首關于花的詩時，
他突然想畫花。

when he starts to write a poem
about this flower,
he suddenly feels like drawing it.

唱不了二句 他突然 想吃花——
花却先把他吃了。

when he begins the song he gets an
urge to eat the flower
but the flower eats him instead.

小明
SIUMING

間諜 SPY

小明是個間諜
Siuming is
a spy

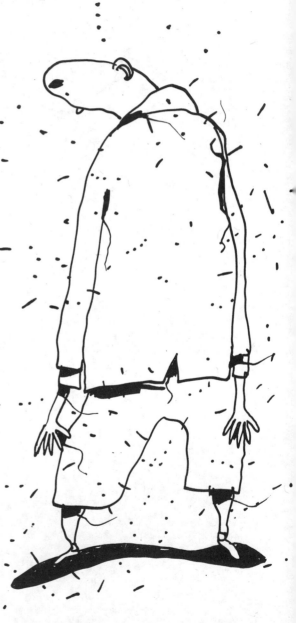

同時他也是個双間諜

and he is a
double agent
at the
same time

他其實是個她的,

More than that
he is in fact
a she.

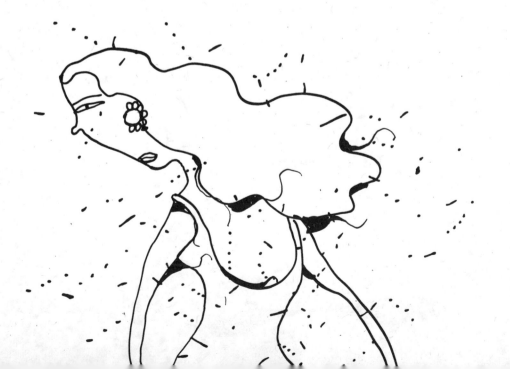

更是一隻裝扮成貓的狗.

and also a dog

disguised as a cat.

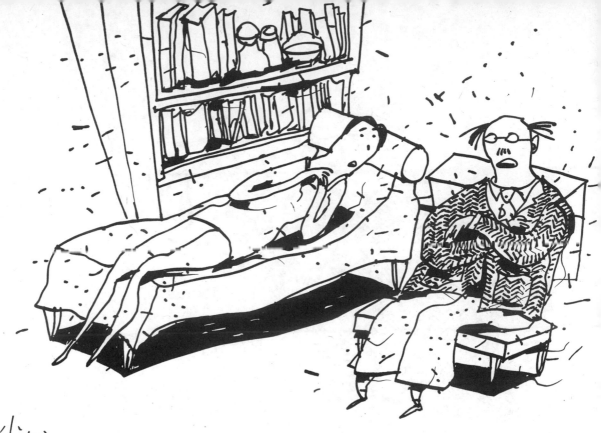

小明精於為他的病人
　　　　解釋一切千奇百怪的夢。
Siuming explains every weird dream
　　　his clients have ever had.

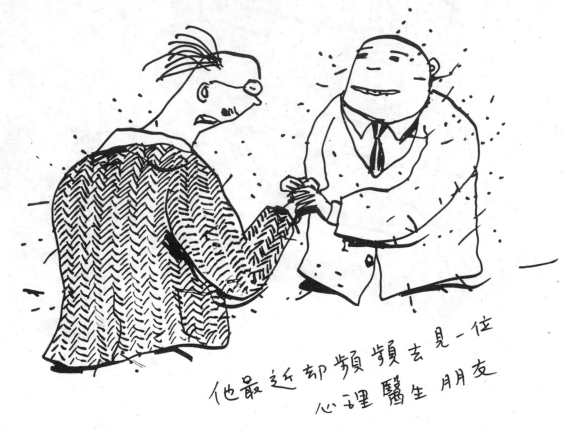

他最近卻頻頻去見一位
心理醫生朋友

Recently SiuMing has been paying
visit
to a friend, who is also a
psychiatrist.

目的是希望明白為甚麼過去
五十年，他自己卻沒有好好做過
　　　　　　　　　　一個夢。

He wants to find out why he hasn't
even had one dream in the
past 50 years.

小明
SIUMING

巴士司機
BUS DRIVER

小明是個巴士司機
Siuming is a bus driver.

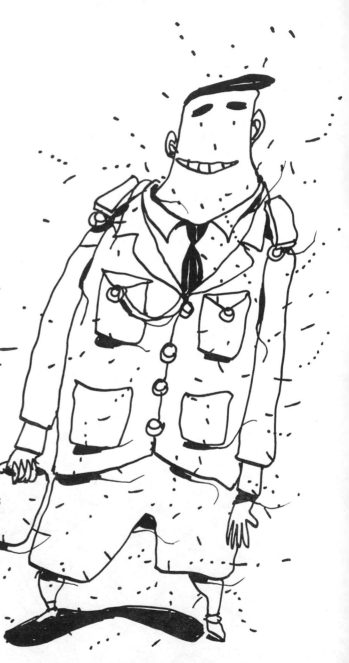

可是他總愛自作主張把乘客帶到
But he likes to take
his passengers wherever
his instinct leads him.

自己喜歡的地方。

想不到他的乘客也樂於有一個
這樣有創意、有冒險精神的司機。
Surprisingly, all his passengers appreciate his creativity and his adventurous act.

難怪每天巴士站前

大排長龍。

It explains why
there is a long queue
at the bus stop all the time.

無語
NOT A WORD

小明是個名聞中外的小說家。
Siuming is a world
famous novelist.

他把一切要說的
都在小說裡說了。

He has said
everything
he has to say
in his
novel.

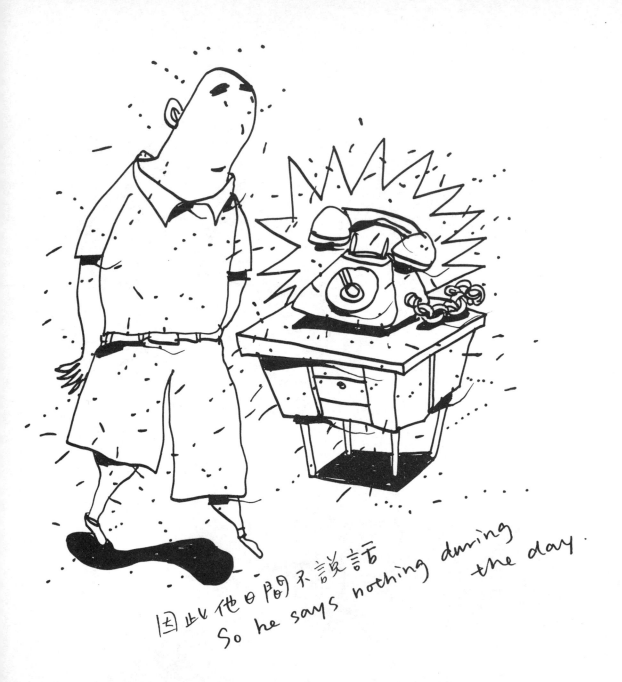

因此他日間不說話
So he says nothing during
the day.

就連晚間也不說話，
And not a single word
at nighttime.

小明
SIUMING

失落
DEPRESSION

周年舞會中
小明突然很失落.

SiuMing. suddenly
finds herself
so depressed
in the middle of
the annual
ball . . .

不是因為沒有英俊的舞伴，
Neither because of not having
a handsome partner.

也不是因為抽不到大獎，
Nor because of not having
the grand Prize.

問題是沒有人跟她穿同一襲裙子，
周刊記者就不會拍她的嘛⋯了。

The problem is that nobody wears
the same dress as hers,
that makes no reporter
take photos of her.

連帶很討厭別人甚至自己的生日。

For this sole reason,
he hates his birthday
and those of his friends.

一據調查所得 是他發明擲生日蛋糕 這個玩意的。
It is said that he is the guy who invented throwing birthday cake at birthday parties.

據紀錄所得他活到一百四十歲。
It is recorded that he lived
to be 140 years old.

因為一停電，他就異常肚餓，

During the blackout he feels extremely hungry.

摸黑到廚房是很危險的事，

Wandering towards the kitchen
in complete darkness
is quite dangerous.

ooh no

而瘋狂的吃一些不知道是什麼的東西
也不太安全 。

and frantically eating
unknown foodstuffs
is unsafe too.

小明
SIUMING

SIUMING'S
NEW CLOTHES

小明的新衣

小明到裁縫那裡做了一件新衣
Siuming has his new clothes made
by a local tailor

試身的時候從裁剪到款式到尺碼都很合意、

During the fittings, the cut and size are perfect.

可是不知怎的在接着的
兩個星期内 小明胖了二十磅

But in the following two weeks
SiuMing suddenly gains
20 pounds.

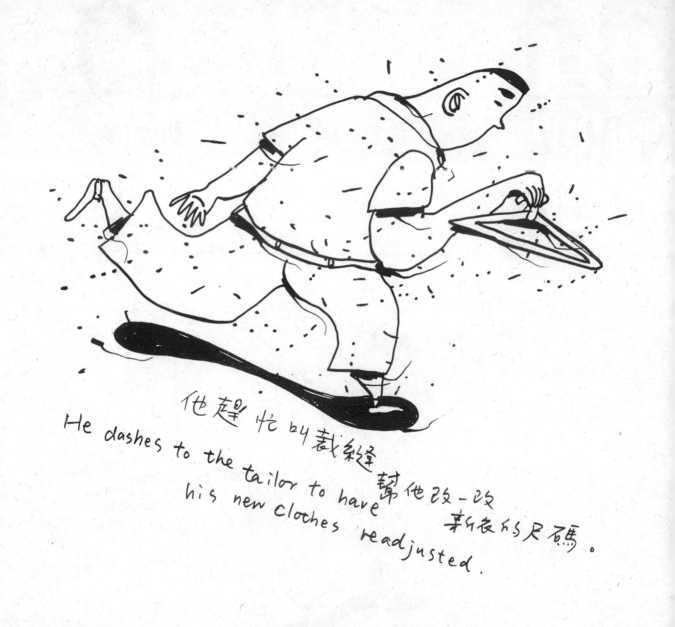

他趕忙 by 裁縫 幫他改一改 新衣的尺碼。

He dashes to the tailor to have
his new clothes readjusted.

SIUMING

說故事
Story telling

小明經常跟人家說
她最喜歡説故事

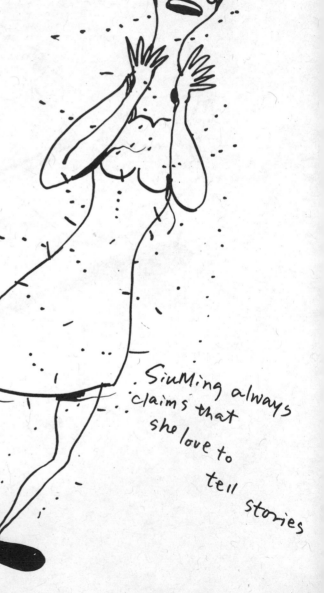

Siuming always
claims that
she love to
tell stories

但她总是把故事A和
　故事B的內容搞亂

But she is so used to mixing up
the content of story A
and story B.

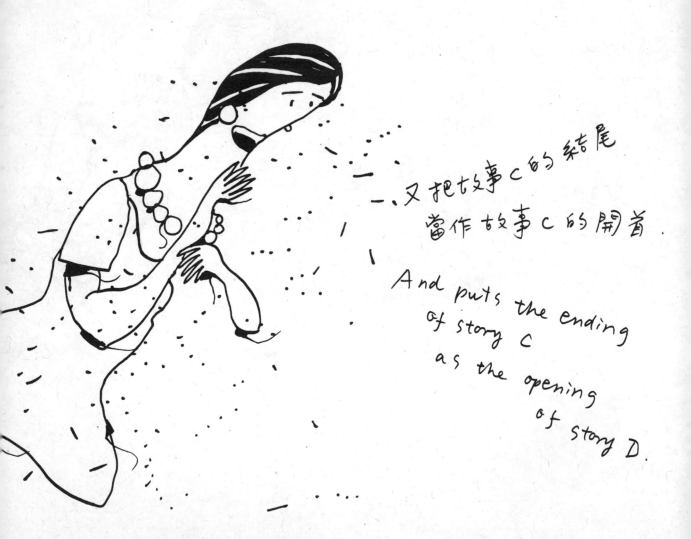

一、又把故事c的結尾
當作故事c的開首.

And puts the ending
of story C
as the opening
of story D.

但大家都十分喜愛這神又創新 又神秘的
　　　　　　　　　　　　　　　說故事方法.
　　　一致公認小明是 最佳的說故事人.
But people just Love this innovative
　　and mysterious method of her
and address her the　　　story telling.
　　greatest story teller.

SIUMING

赤裸裸
THE NAKED GAME.

小明對自己無懈可擊的身材
絕對滿意。
Siuming is fully satisfied with
his faultless figure.

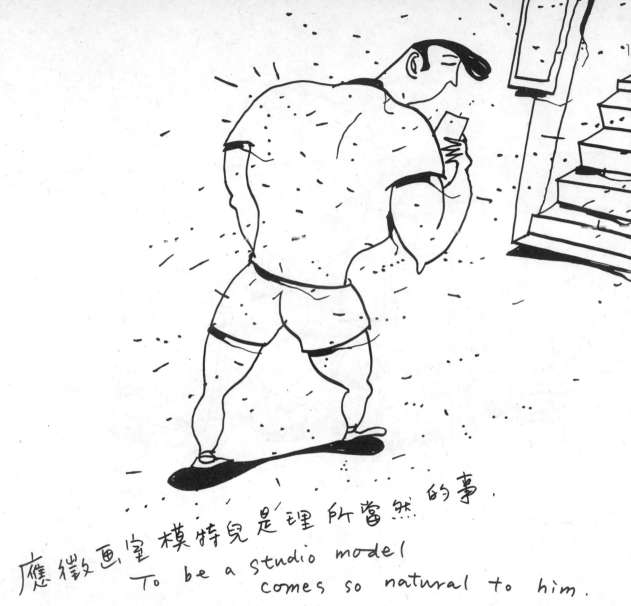

應徵畫室模特兒是理所當然的事.
To be a studio model
comes so natural to him.

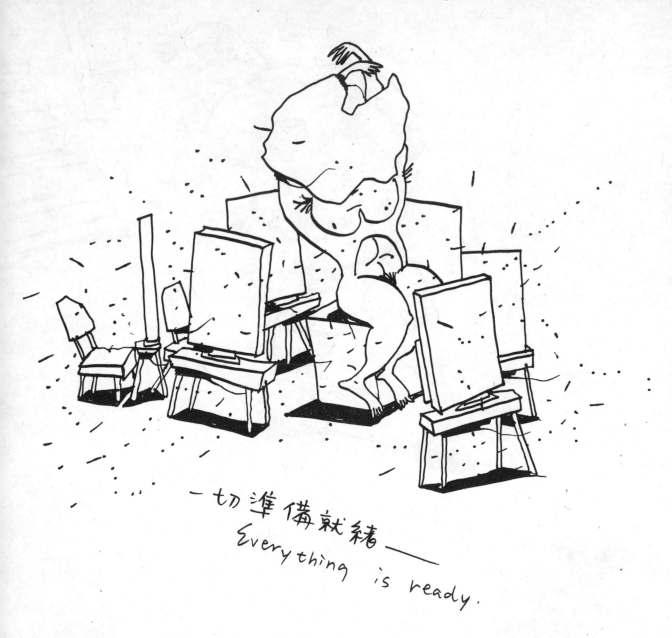

一切準備就緒──
Everything is ready.

想不到赤裸裸的是藝術家。

Surprisingly, the studio is packed with naked artists instead.

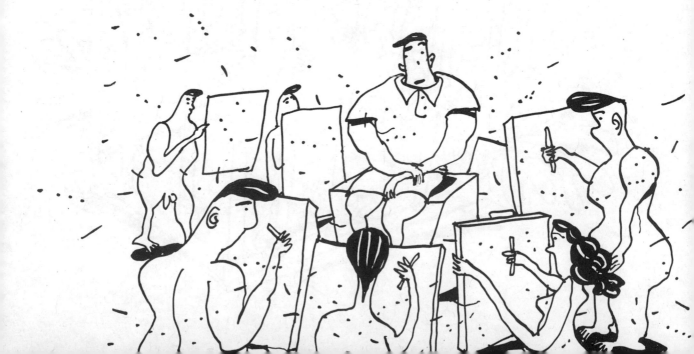

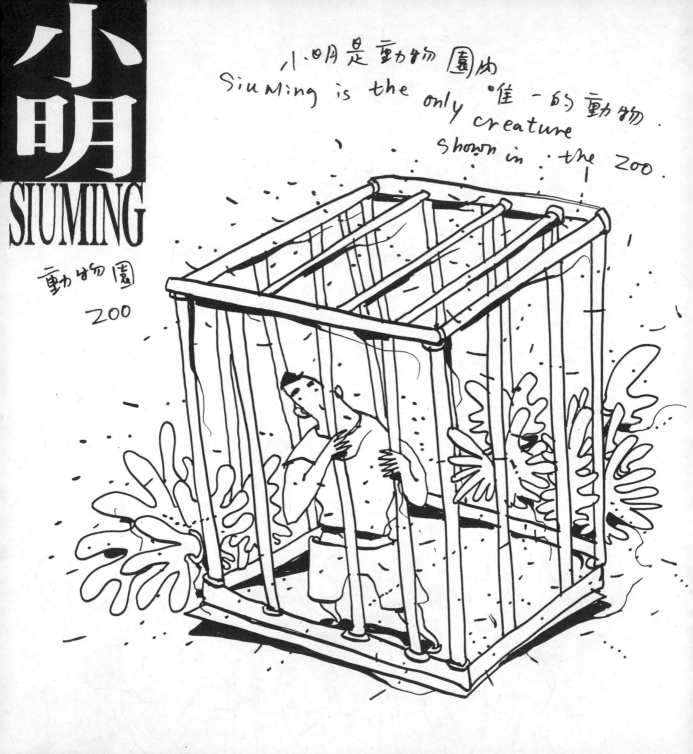

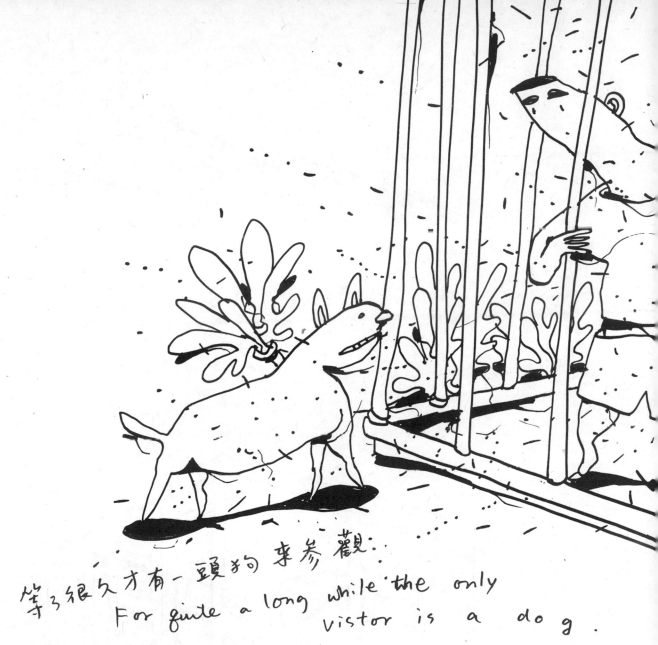

等了很久才有一頭狗來參觀.
For quite a long while the only
vistor is a dog.

小明用盡方法把狗引入籠裡，

Using all his effort, SiuMing manages to get the dog into the cage.

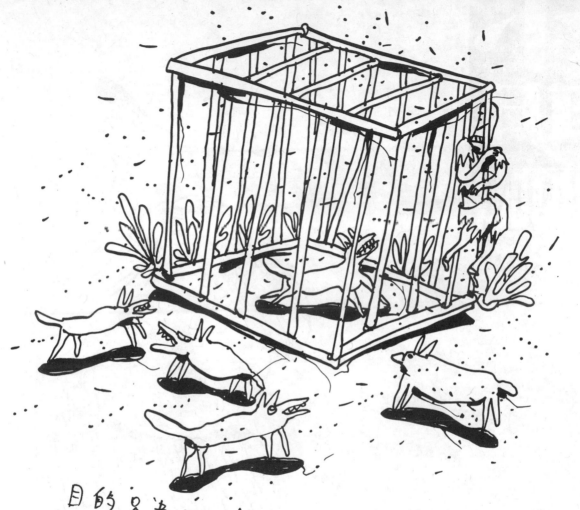

目的只為可以帶給大家多一點歡樂。

The aim is to give more fun to the coming visitors.

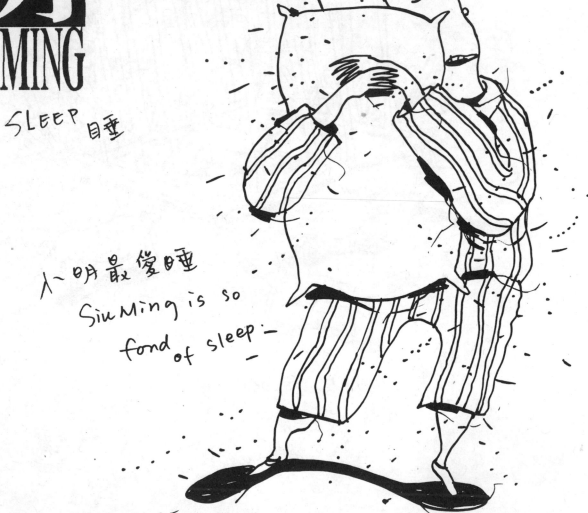

小明
SIUMING

SLEEP 睡

小明最愛睡
Siuming is so
fond of sleep

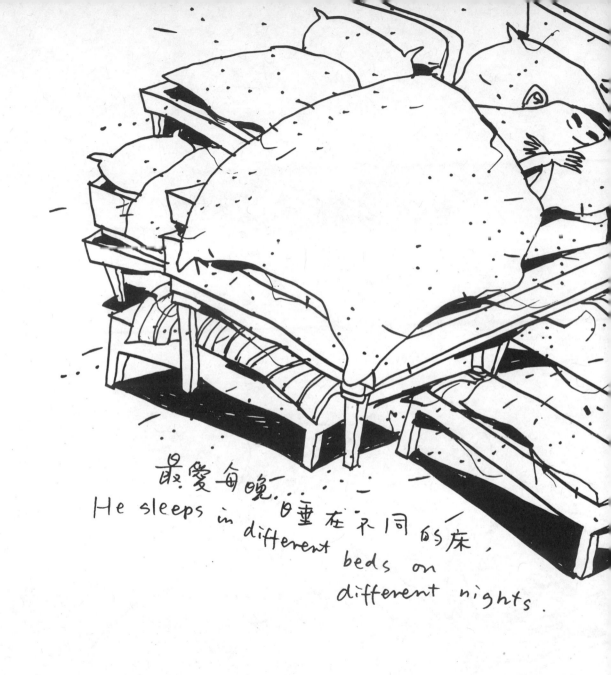

最愛每晚 睡在不同的床，

He sleeps in different beds on different nights.

不同的床有不同的玩具.
there are different toys
in different beds

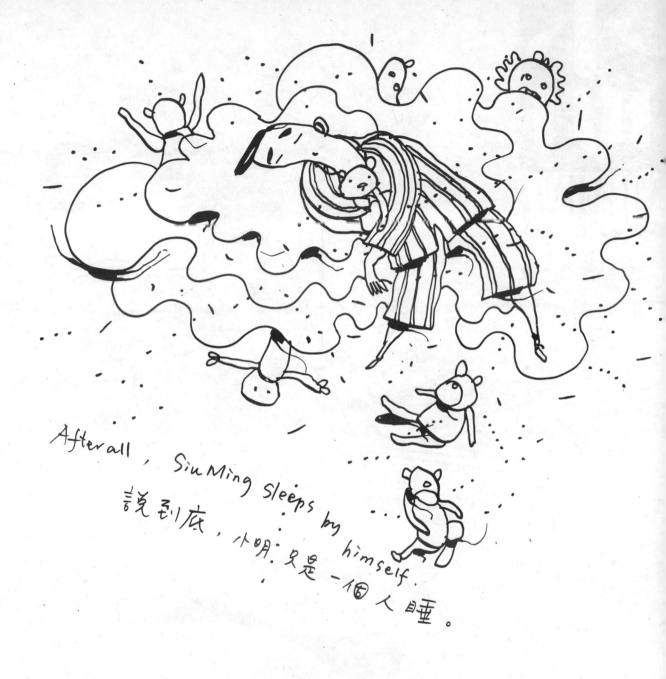

After all, Siu Ming sleeps by himself.

說到底，小明，又是一個人睡。

小明
SIUMING

床邊故事

Bedtime Stories

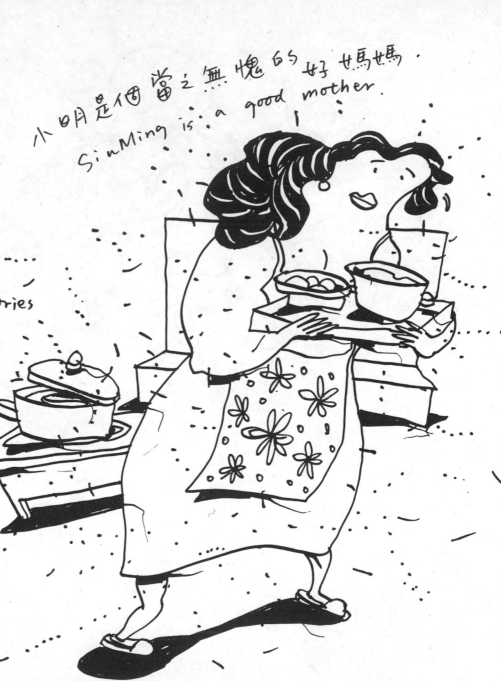

小明是個當之無愧的好媽媽.

SiuMing is a good mother.

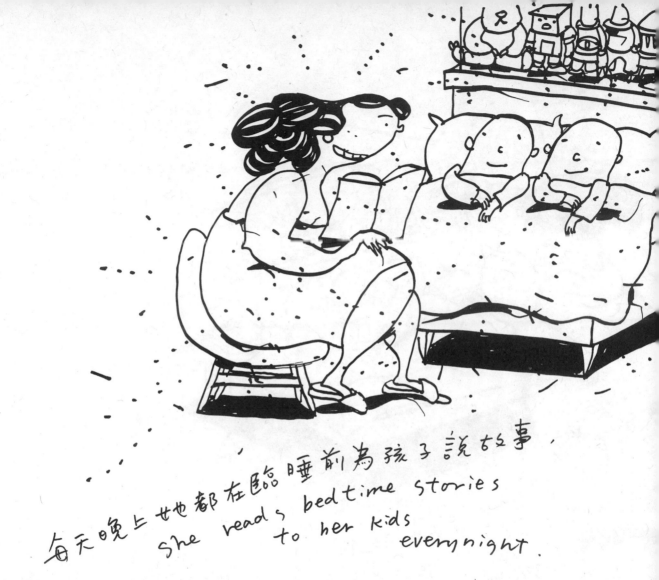

每天晚上她都在臨睡前為孩子說故事.

she reads bedtime stories
to her kids
everynight.

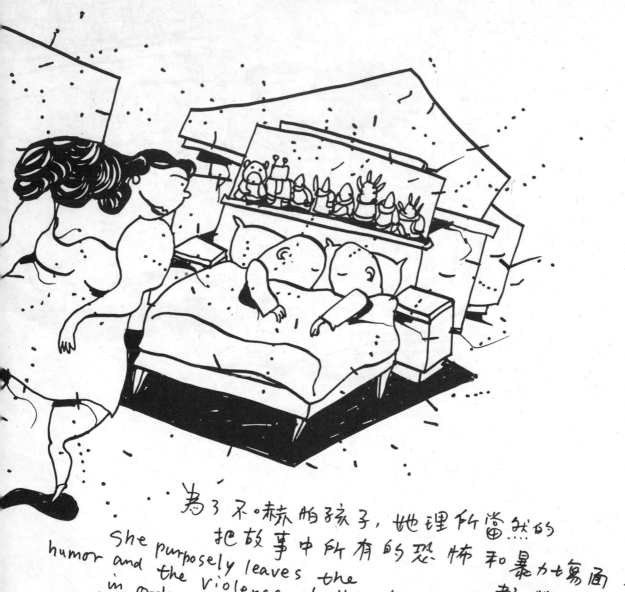

為了不。赫的孩子，她理所當然的
把故事中所有的恐怖和暴力場面
都刪去……

She purposely leaves the
humor and the violence of the stories untold,
in order not to frighten the Kids.

刺激的當然留給自己。

She reserves all the excitement
for herself

小明
SIUMING

來客 MAN FROM MARS

小明實在不知道
他為什麼這樣出名

Siuming does not
understand why
he is so famous.

無論到哪裡，他都受到大家的
簇擁歡迎。
He is greeted by everyone
he encounters on the street.

售貨女郎給他折扣.廚師給他吃最好的
連聖誕老人也給他額外的禮物。
He is given discounts in stores.
bigger portions in restaurants
and receives extra gifts from
Father Christmas.

小明暗自高興之餘，
也實在納悶為什麼
從來沒有人知道
他是火星來客。

He is quite happy about
all of these,
but the only thing he is
disappointed about
is that no one knows
that he is from Mars.

小明
SIUMING

蛻變
MALMETAMORPHOSIS

一覺醒來小明發覺自己 變了一隻昆虫.
SiuMing finds he has become an insect when he wakes up one morning.

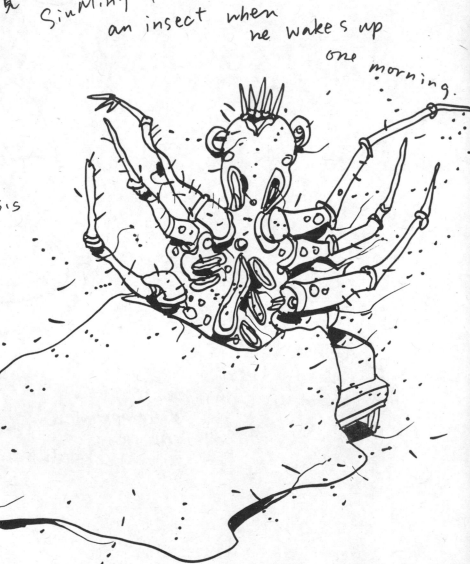

叫他傷感的是
　　他本來打算變成
　　　　一隻香蕉

He is so sad because his original aim
was to become a banana.

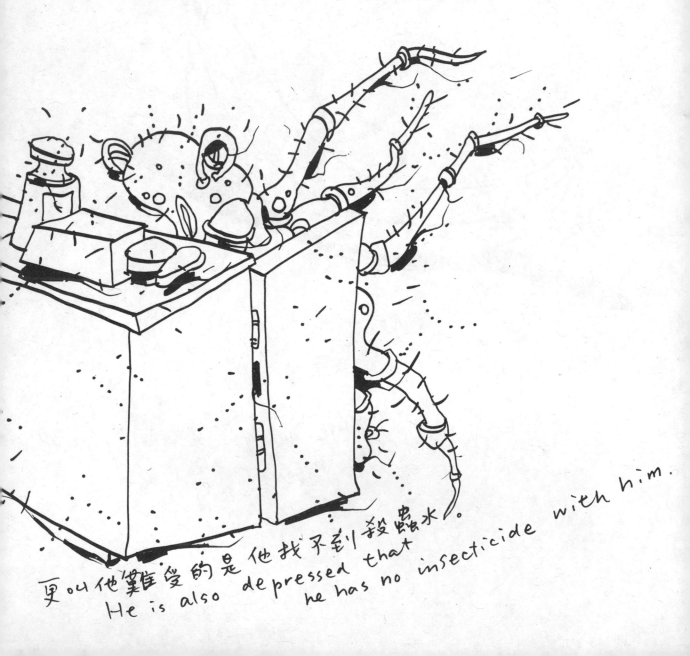

更叫他難受的是他找不到殺蟲水。
He is also depressed that he has no insecticide with him.

最最失望的是作為一隻昆虫他實在很醜。
And the most disappointing fact is that even by an insects standard. he is very ugly indeed.

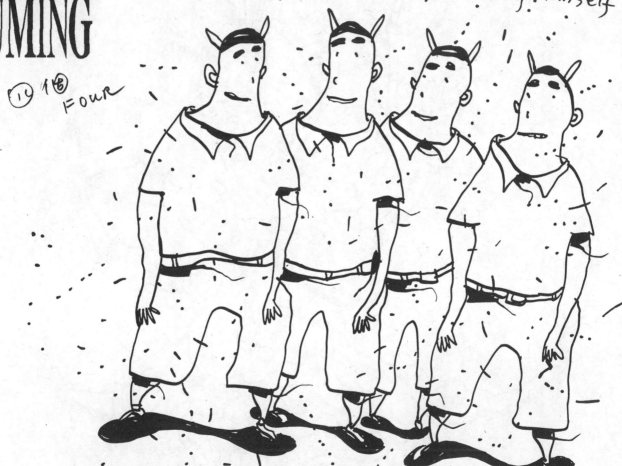

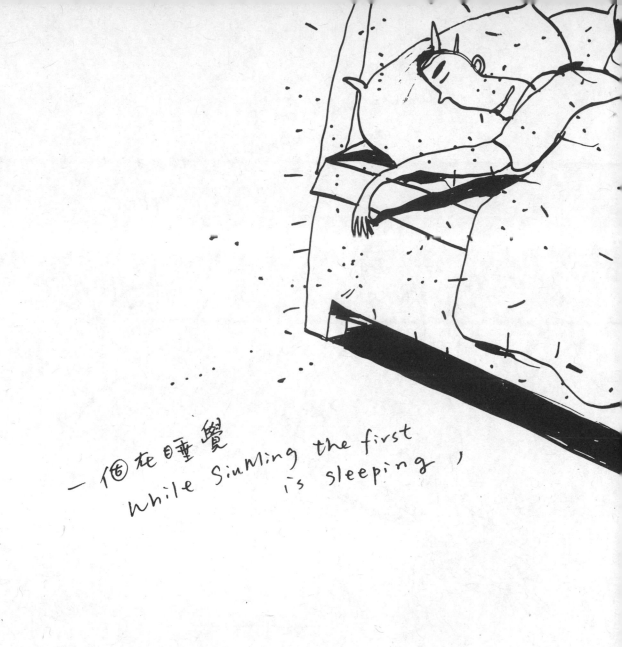

一個在睡覺
while SiuMing the first
is sleeping,

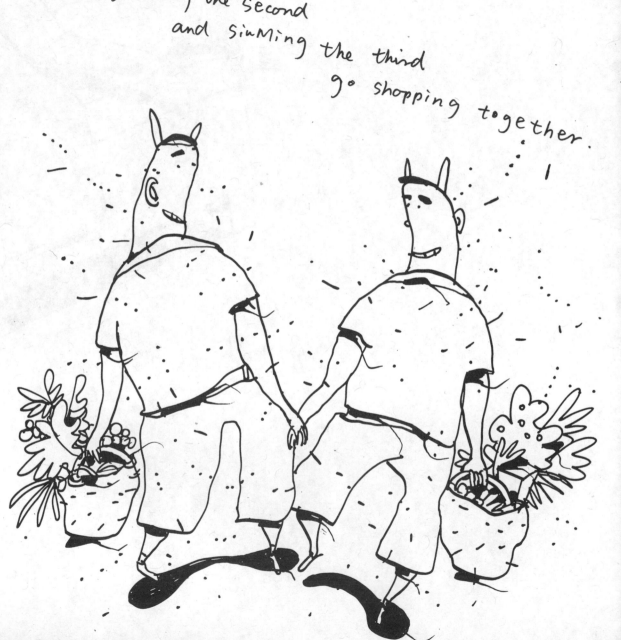

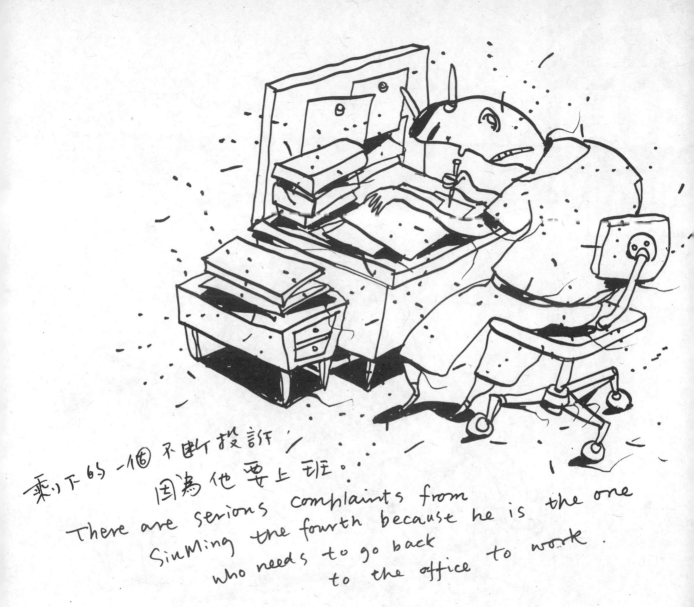

剩下的一個不斷投訴，
因為他要上班。
There are serious complaints from
SiuMing the fourth because he is the one
who needs to go back
to the office to work.

小明
SIUMING

分享
SHARE

小明婆婆 德高望重.
Grandma SiuMing
is such a respectable
old Lady.

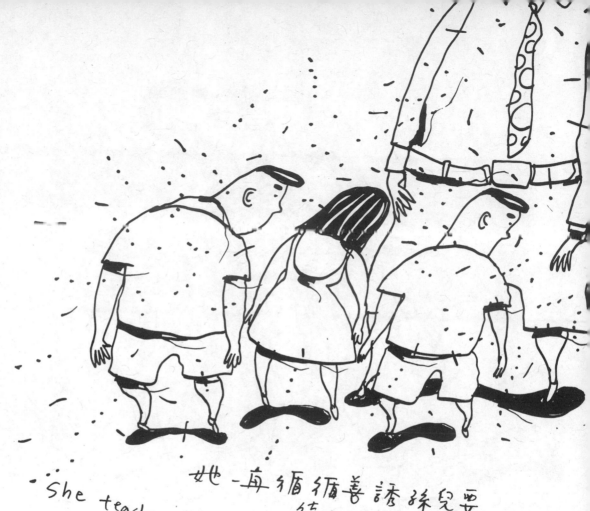

她一再循循善誘孫兒要
待人以禮 尊敬長輩.

She teaches her grandchildren
again and again that one should
curtesy to the elderly.

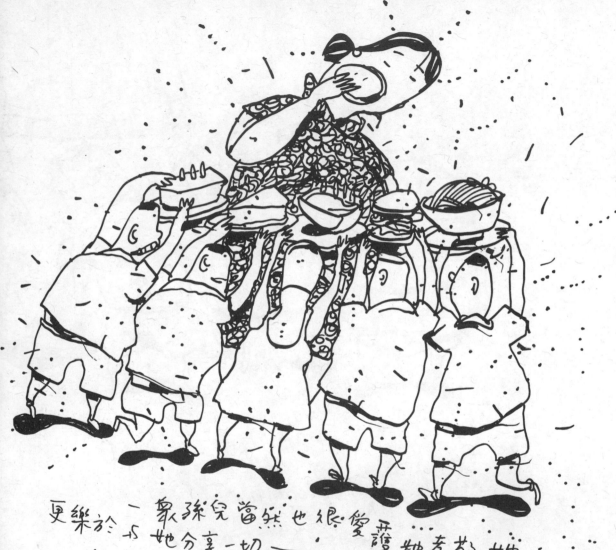

更樂於 一 群孫兒當然也很愛護
她分享一切 — 她孝敬她

All her grandchildren adore her so much.
they never hesitate to share
every thing with her.

也因為分享得太多太急，導致嚴重後果。

Unfortunately she shares too much
and has to be hospitalized.

小明
SIUMING

探險家
EXPLORER

聽說小明是當今世上最偉大的探險家。
It is said that SiuMing is the world's greatest explorer

又聽說他上天下地
　　　走到世界盡頭.

It is said that he goes all the way
to the world's end.

他去的地方大抵沒有郵遞服務
傳真設備諸如此類。
The places he goes have
no postal service,
no fax machine
and no other kind of
communication means.

實在沒有人知道他到過哪裡？
　　　做過甚麼？
　他沒有出版任何遊記
　　　他一去不回。

After all, noone knows what
　　　exactly he does
and where exactly he goes,
　he publishes
　　　no travel log.
　he does not come back.

小明
SIUMING

死 DEAD

小明死了。
SiuMing is dead.

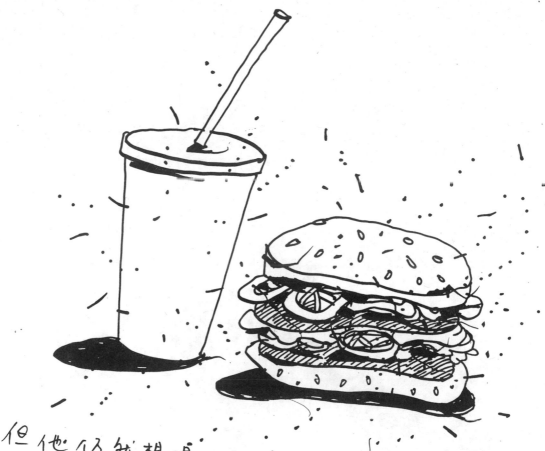

但他仍然想喝可樂，想吃漢堡包

But he still wants to eat a hamburger
and to drink a cup of coke

更想和闊別二十年的前度女友見一見面

and he also wants to meet an ex-girl friend he has not met with for 20 years.

但事實上，小明真的死了

but as a matter of fact,

SiuMing is dead.

SIUMING

身份 ID

小明其實不是一頭狗
SiuMing is in fact
, not a dog

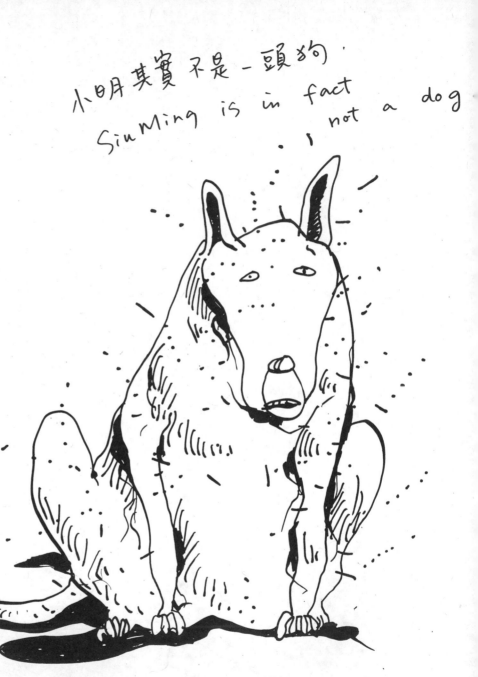

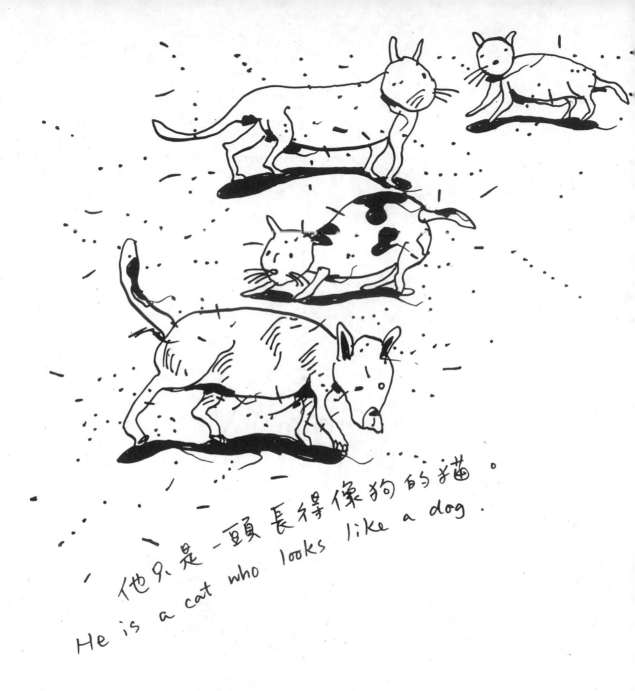

他只是一頭長得像狗的貓。

He is a cat who looks like a dog.

最近小明碰上一個主人，後他像愛一隻鳥

Recently SiuMing meets a master who loves him and treats him like a bird.

他開始有點模糊，決定投胎做一條魚。

He starts to puzzle about his identity
and decides to reincarnate
as a fish.

關於作者

歐陽應霽. 漫畫創作人.
　發表漫畫及文字創作於港. 台報章雜誌。
結集作品包括:《我的天》一至三冊
　漫畫
　　　　　《三七女一》,《廢画》 《小明》
　　　　　　　　　《我的天使》
　漫画咭
　　《想你》,《三四一十二》
　　《我是你的 你是我的》《是!我是!》
　　　　　　　　文字 極短篇《一日一日》

About The Author

Craig An Yeung, a comix artist from Hongkong.
He has his regular comix and writing columns
in a number of Hongkong
and Taiwan newspapers
and magazines.

Published comix albums include:
《 My own private heaven 》 issue 1-3
《 Three times seven equals to Twenty-one 》
《 FÈ HÙA' 》 《 SiuMing 》 《 Angels in My heart 》
and sets of comixcards.
also a collection of short fiction 《 Day in Day out 》.

國家圖書館出版品預行編目資料

小明 / 歐陽應霽漫畫 . -- 初版 . -- 臺北市：
大塊文化，1997〔民86- 〕
面； 公分 . -- (Catch；13)

ISBN 957-8468-35-0（平裝）

947.41　　　　　　86014369

catch 13

小明 SIUMING

作者／翻譯：歐陽應霽

英文校對：DEAN NAPOLITANO

發行人：廖立文

出版者：大塊文化出版股份有限公司

台北市羅斯福路六段142巷20弄2-3號

讀者服務專線：080-006689

TEL：(02)9357190　FAX：(02)9356037

信箱：新店郵政16之28號信箱

郵撥帳號：18955675

帳戶名：大塊文化出版股份有限公司

e-mail：locus@ms12.hinet.net

行政院新聞局版北市業字第706號

總經銷：北城圖書有限公司

地址：台北縣三重市大智路139號

TEL：(02)9818089（代表號）FAX：(02)988 3028　9813049

製版：源耕印刷事業有限公司

初版一刷：1997年12月

定價：新台幣一百五十元

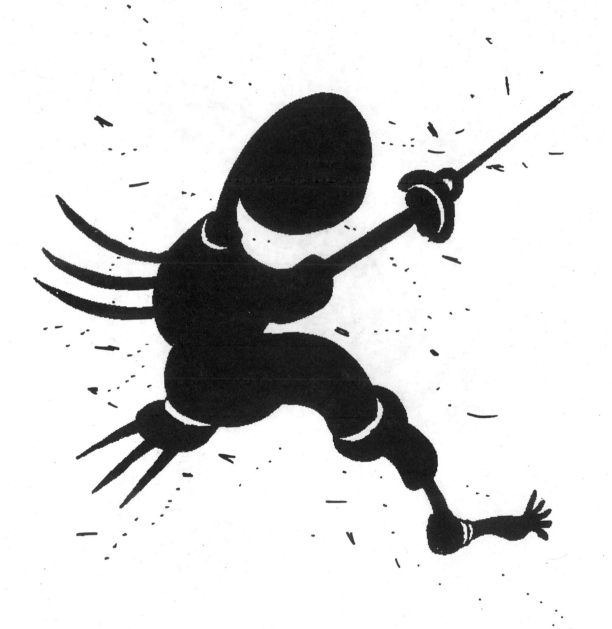

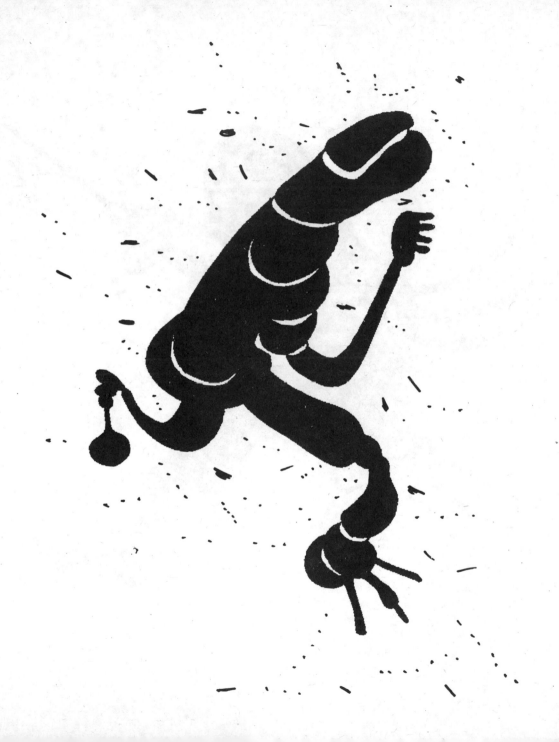

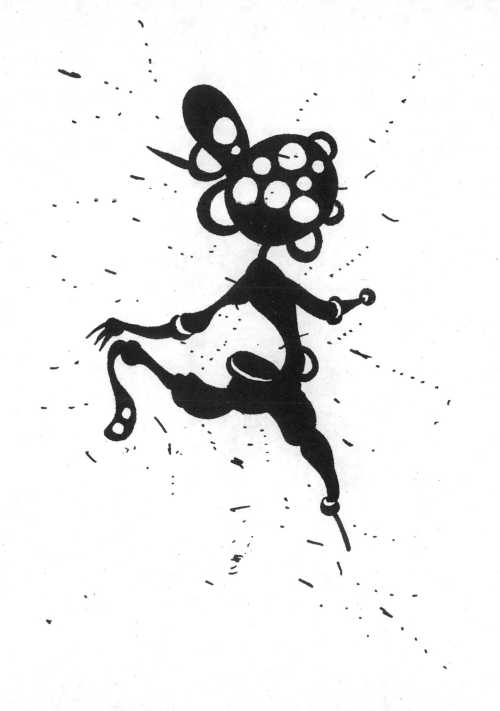

台北市羅斯福路六段142巷20弄2-3號

廣 告 回 信
台灣北區郵政管理局登記證
北台字第10227號

大塊文化出版股份有限公司　收

地址：＿＿＿＿市／縣＿＿＿＿鄉／鎮／市／區＿＿＿＿路／街＿＿＿段＿＿巷

弄＿＿＿號＿＿＿樓

姓名：

編號：CA013　　書名：小明

大塊
LOCUS
文化

讀者回函卡

謝謝您購買這本書，為了加強對您的服務，請您詳細填寫本卡各欄，寄回大塊出版 (免附回郵) 即可不定期收到本公司最新的出版資訊，並享受我們提供的各種優待。

姓名：＿＿＿＿＿＿＿＿＿　身分證字號：＿＿＿＿＿＿＿＿＿

住址：＿＿＿＿＿＿＿＿＿＿＿＿＿＿＿＿＿＿＿＿

聯絡電話：(O)＿＿＿＿＿＿＿＿　(H)＿＿＿＿＿＿＿＿

出生日期：＿＿＿年＿＿月＿＿日

學歷：1.□高中及高中以下　2.□專科與大學　3.□研究所以上

職業：1.□學生　2.□資訊業　3.□工　4.□商　5.□服務業　6.□軍警公教
7.□自由業及專業　8.□其他＿＿＿＿

從何處得知本書：1.□逛書店　2.□報紙廣告　3.□雜誌廣告　4.□新聞報導
5.□親友介紹　6.□公車廣告　7.□廣播節目8.□書訊　9.□廣告信函
10.□其他＿＿＿＿＿

您購買過我們那些系列的書：
1.□Touch系列　2.□Mark系列　3.□Smile系列

閱讀嗜好：
1.□財經　2.□企管　3.□心理　4.□勵志　5.□社會人文　6.□自然科學
7.□傳記　8.□音樂藝術　9.□文學　10.□保健　11.□漫畫　12.□其他＿＿

對我們的建議：＿＿＿＿＿＿＿＿＿＿＿＿＿＿＿＿＿
＿＿＿＿＿＿＿＿＿＿＿＿＿＿＿＿＿＿＿＿＿＿＿
＿＿＿＿＿＿＿＿＿＿＿＿＿＿＿＿＿＿＿＿＿＿＿

LOCUS

LOCUS

LOCUS

LOCUS